Blk Magick

Adult coloring series

Warning!
The content in this book is for mature audiences
All rights reserved

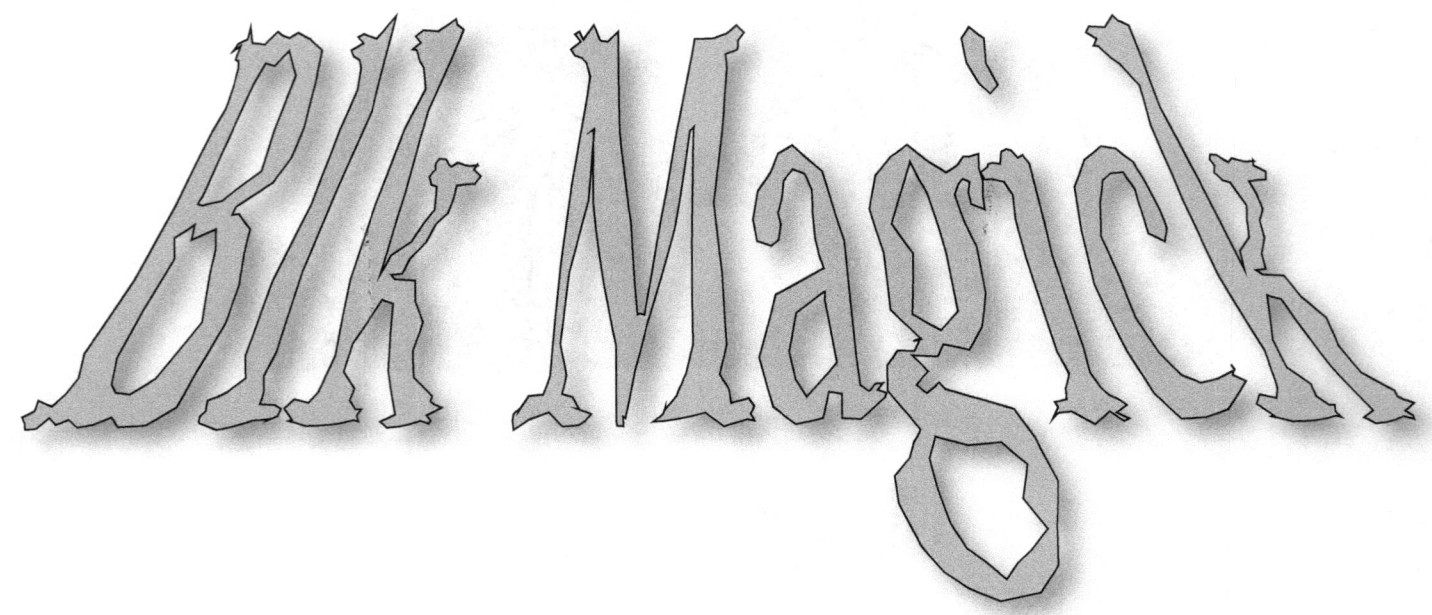

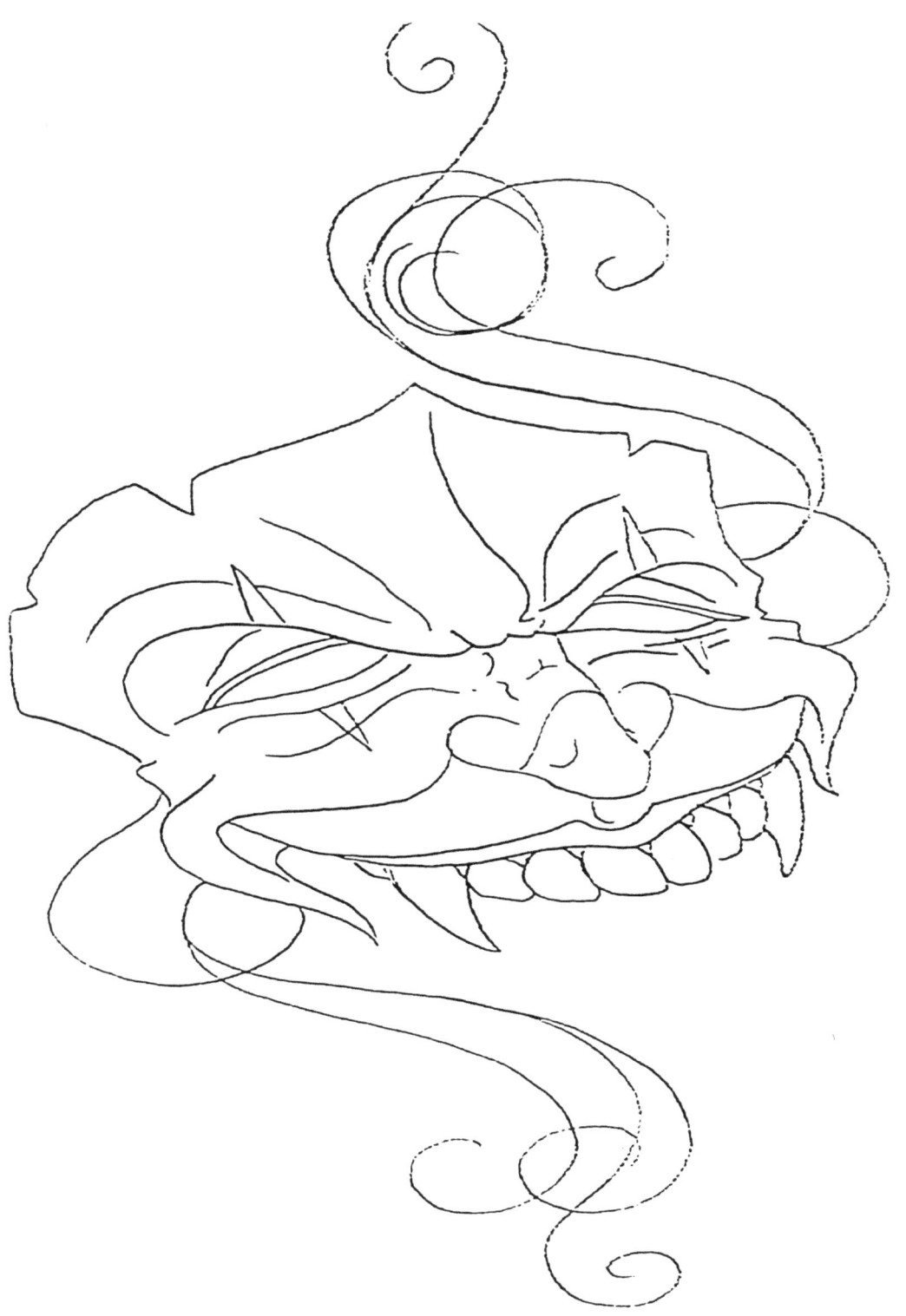

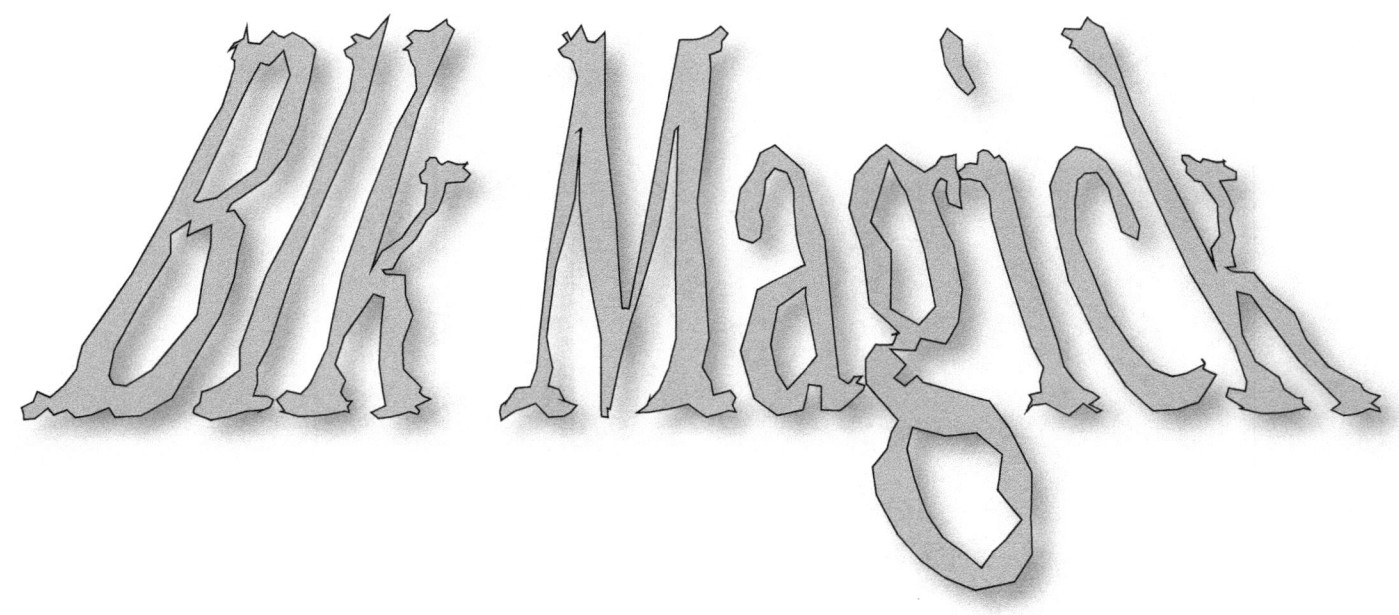

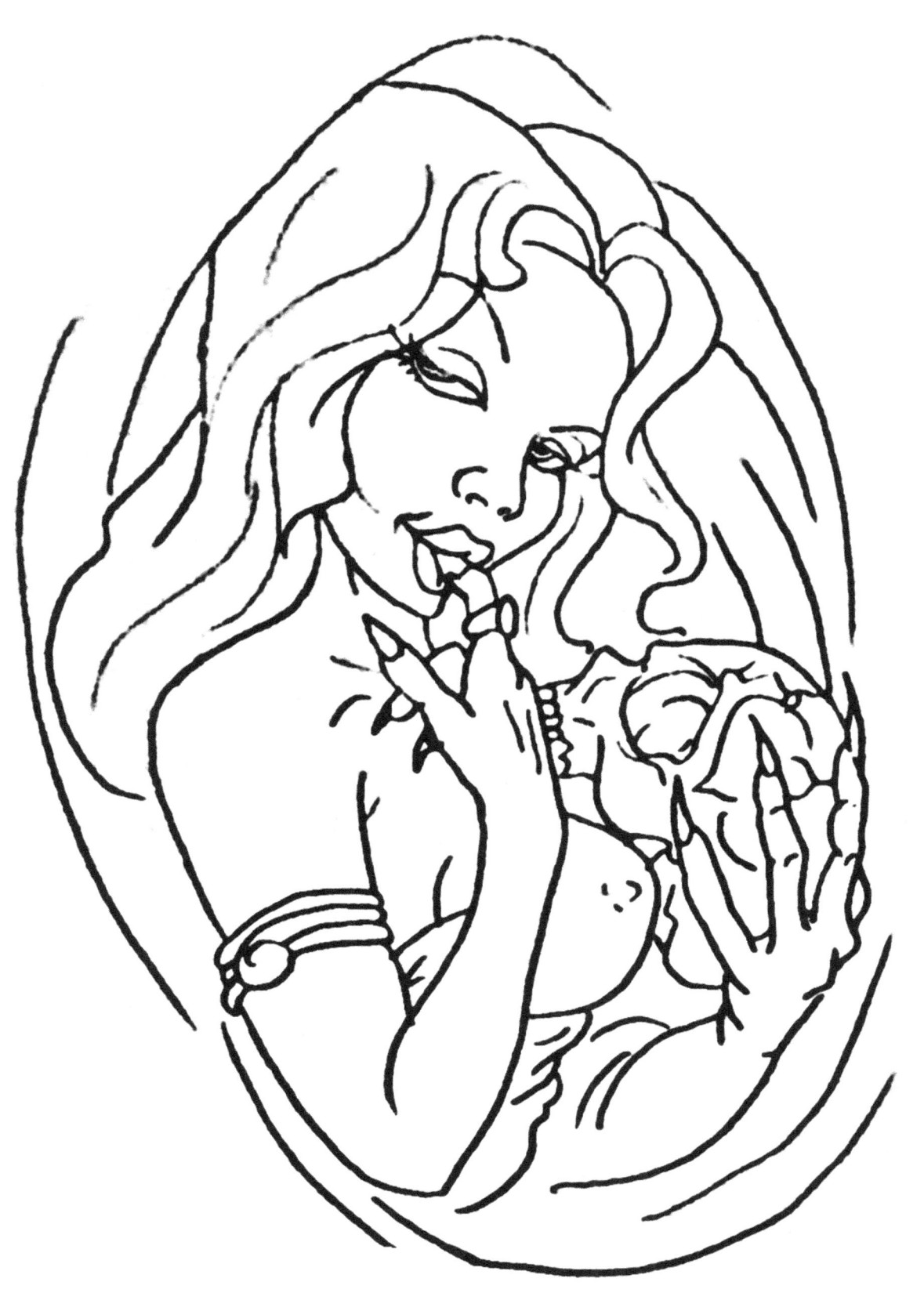

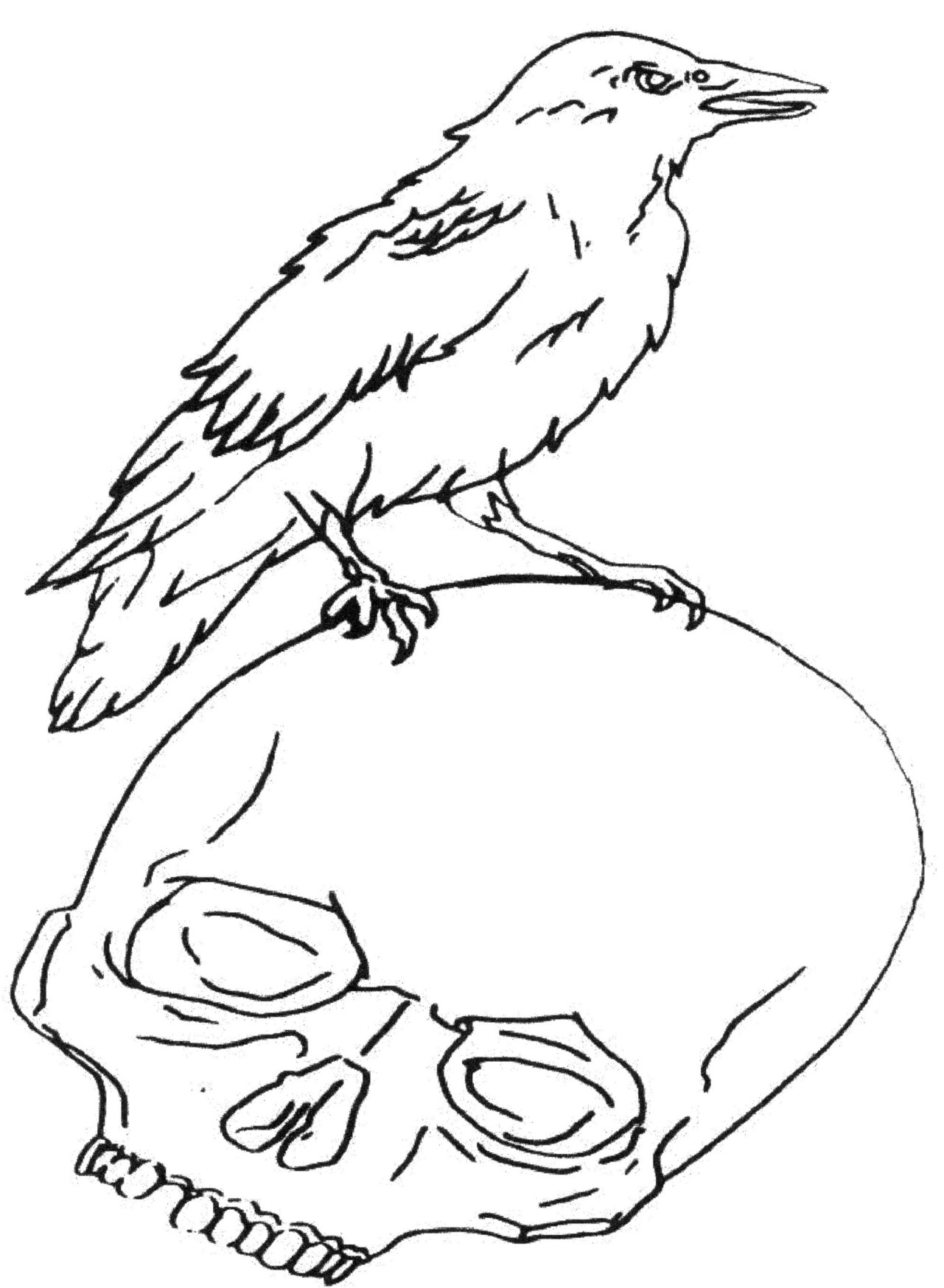

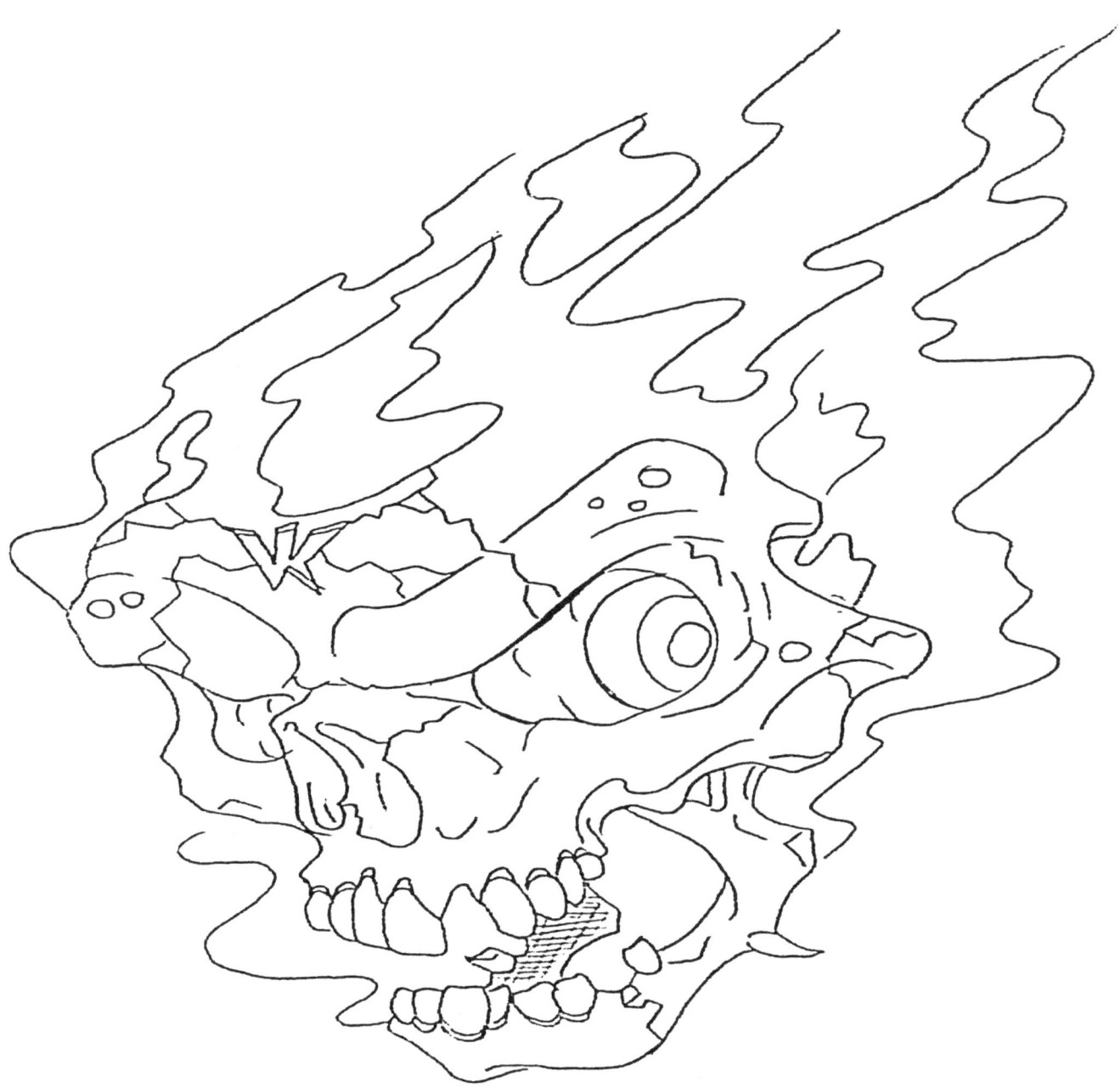

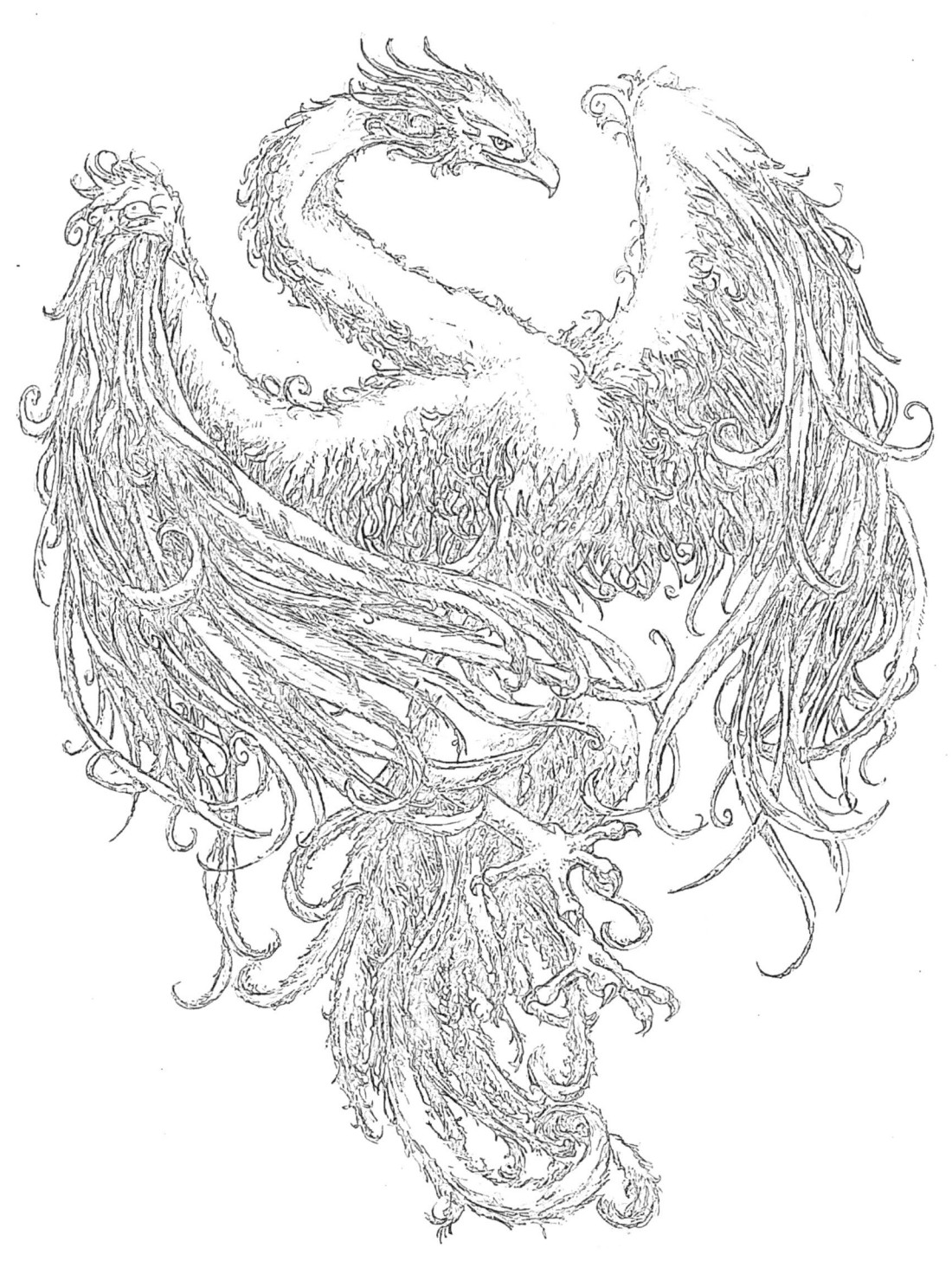

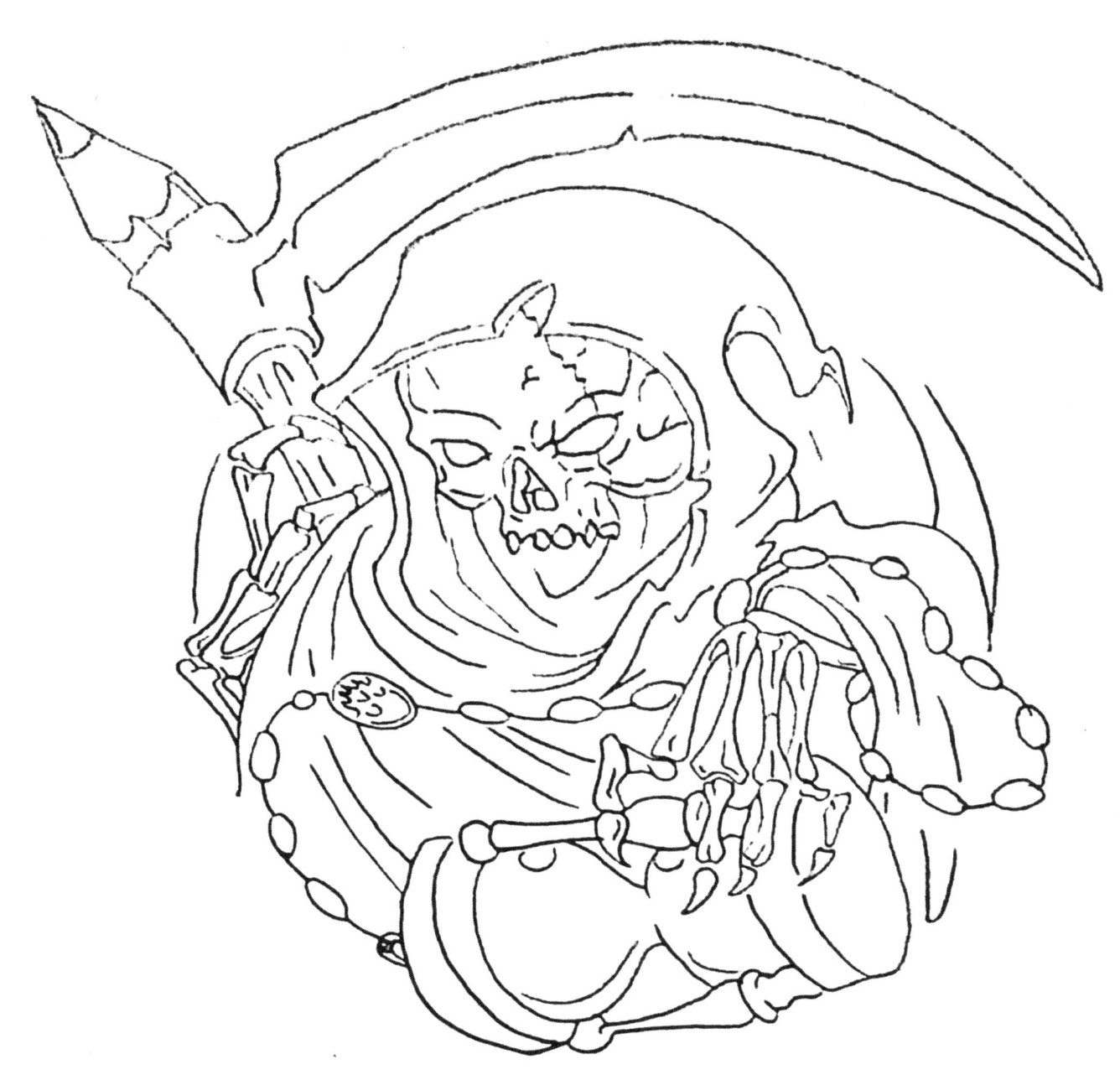

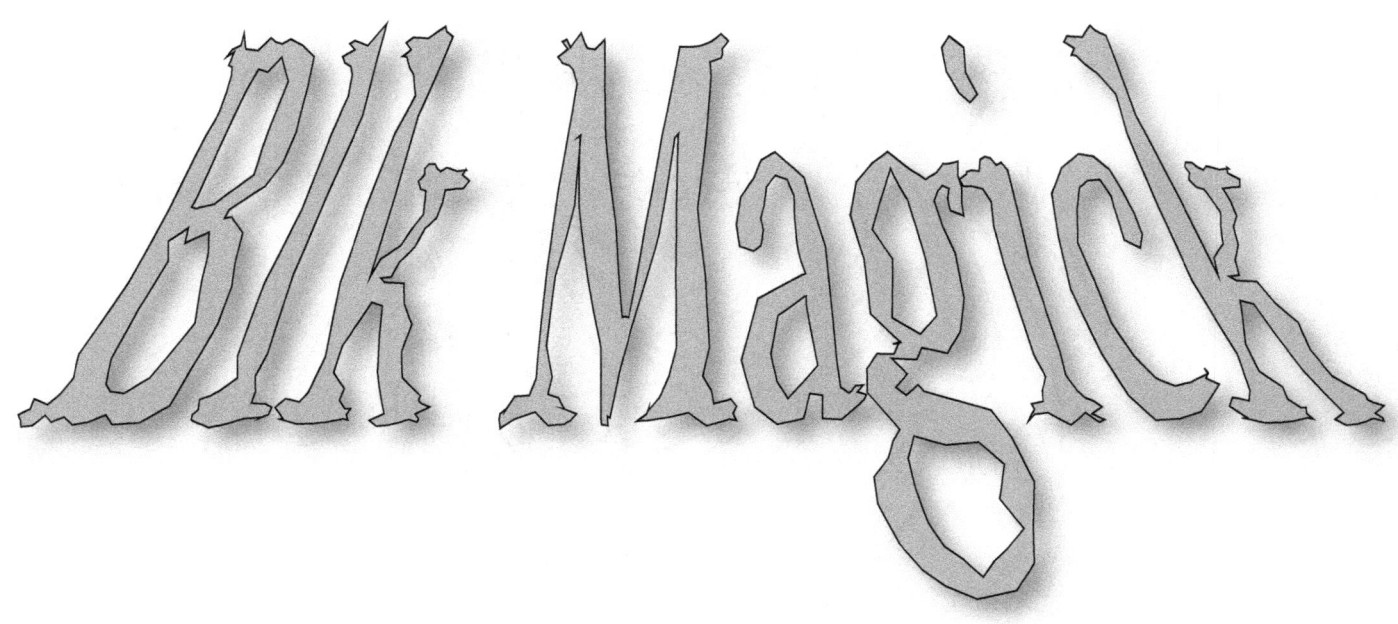

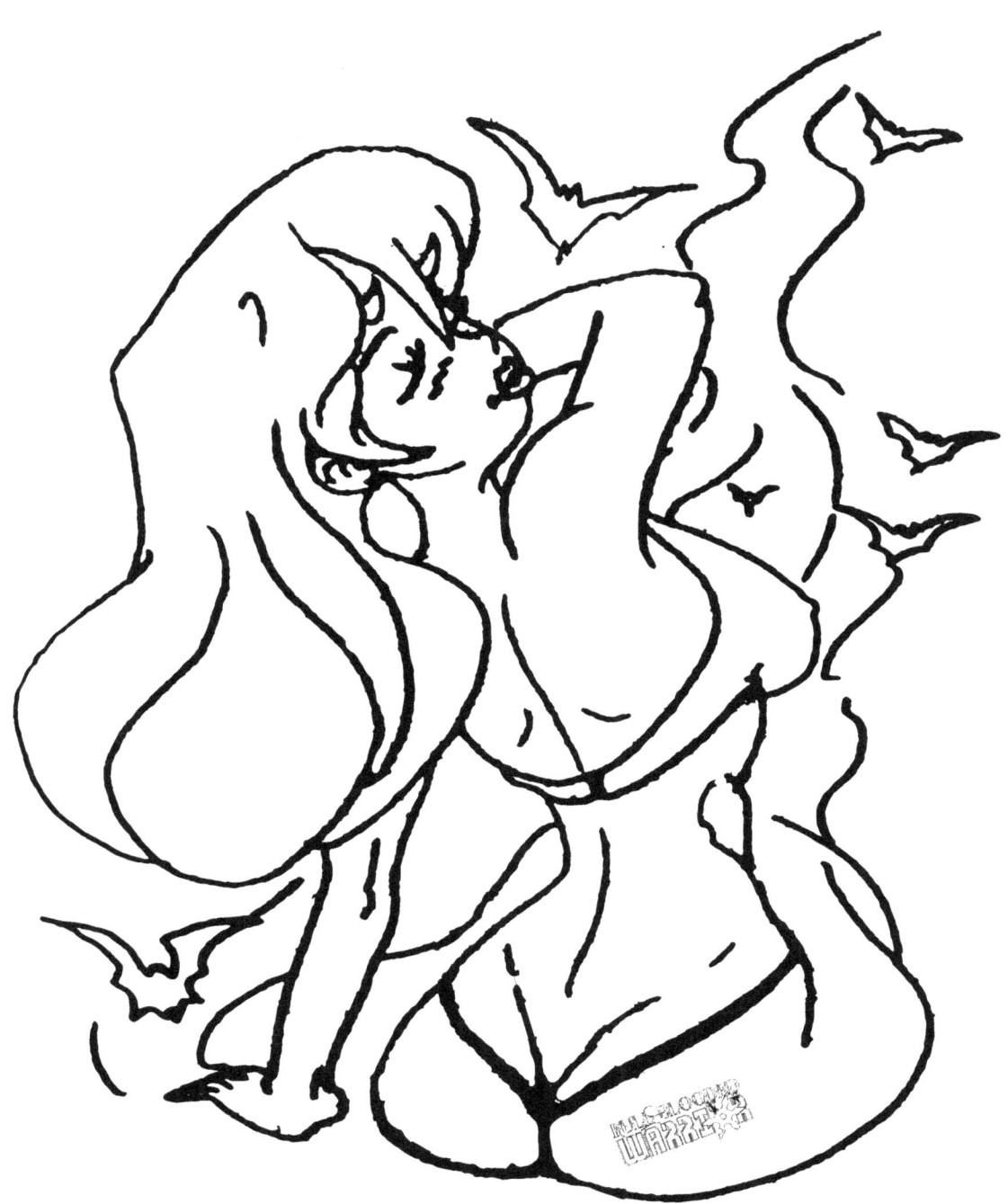

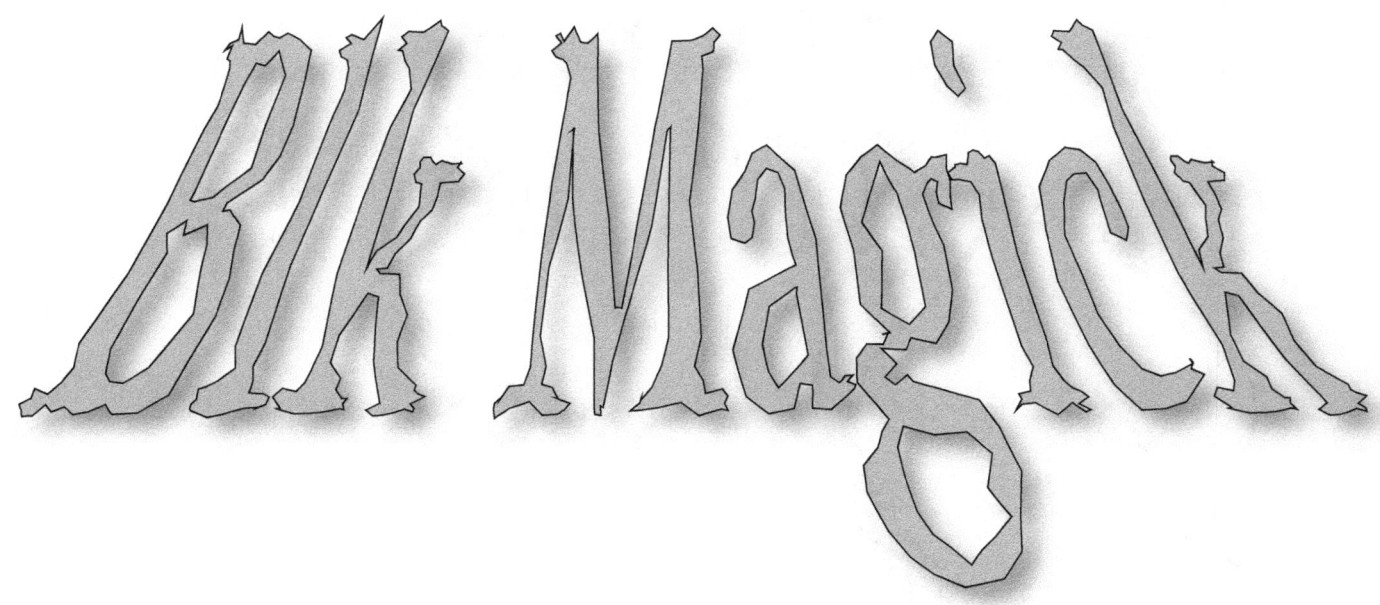

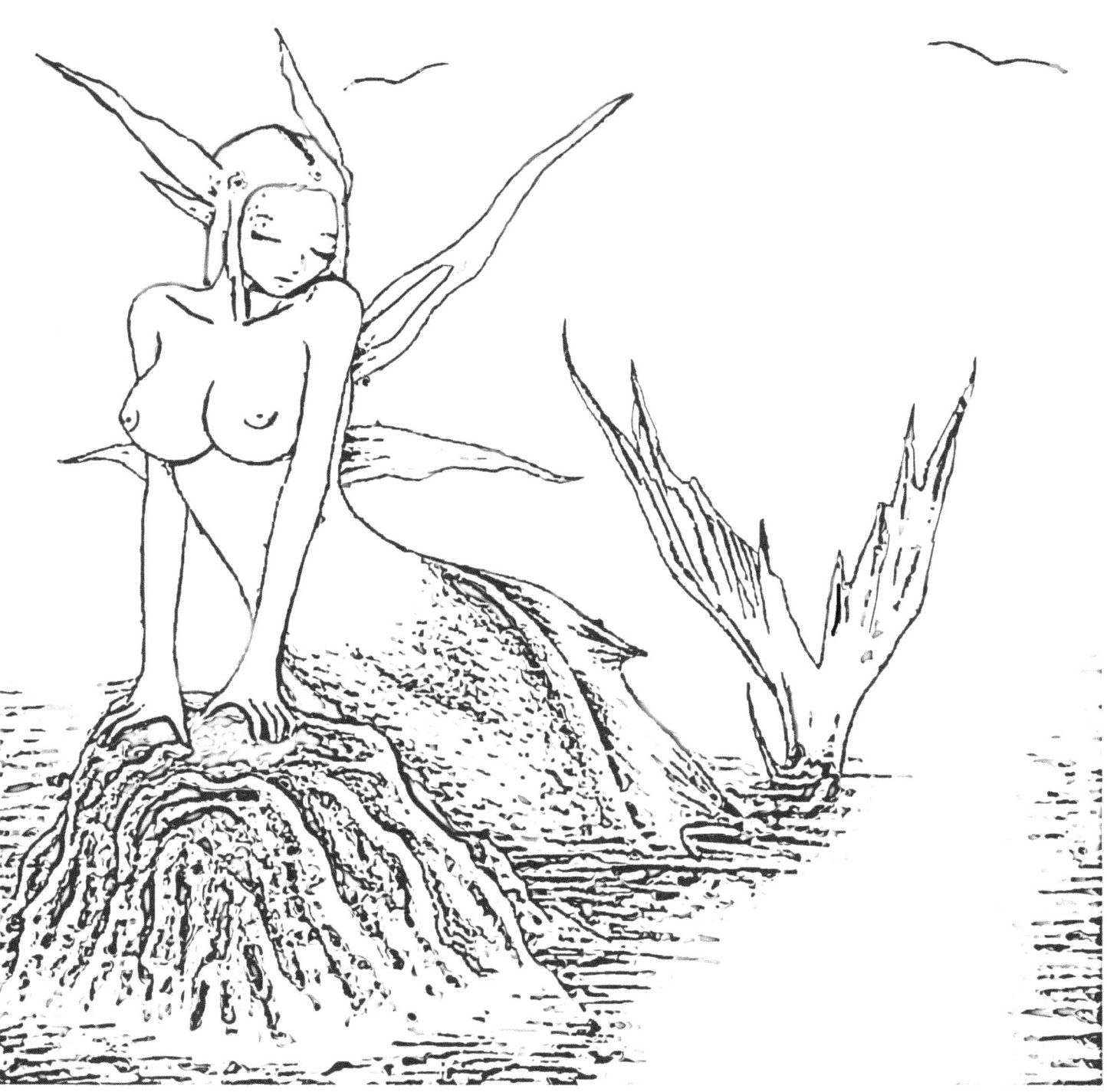

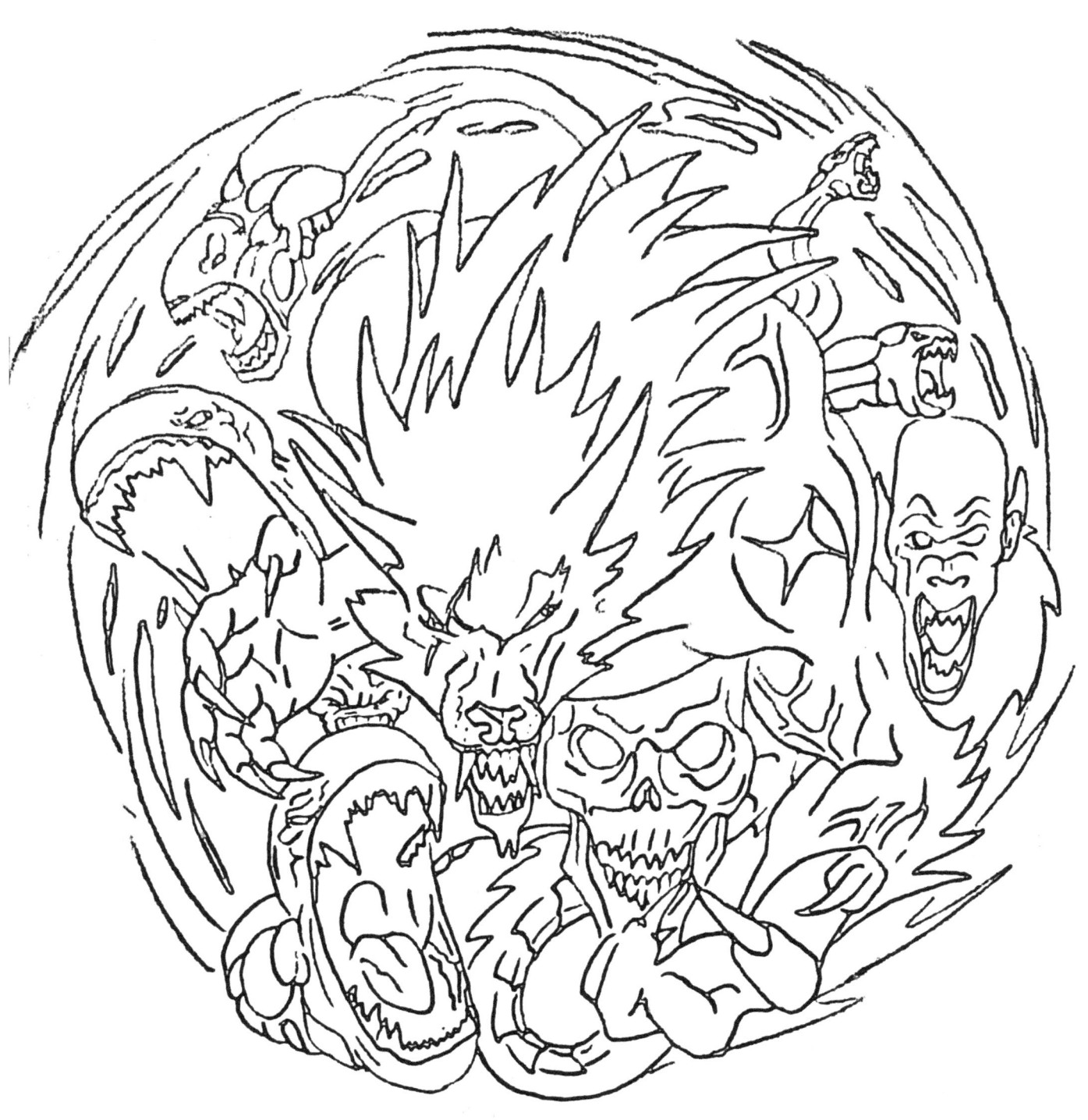

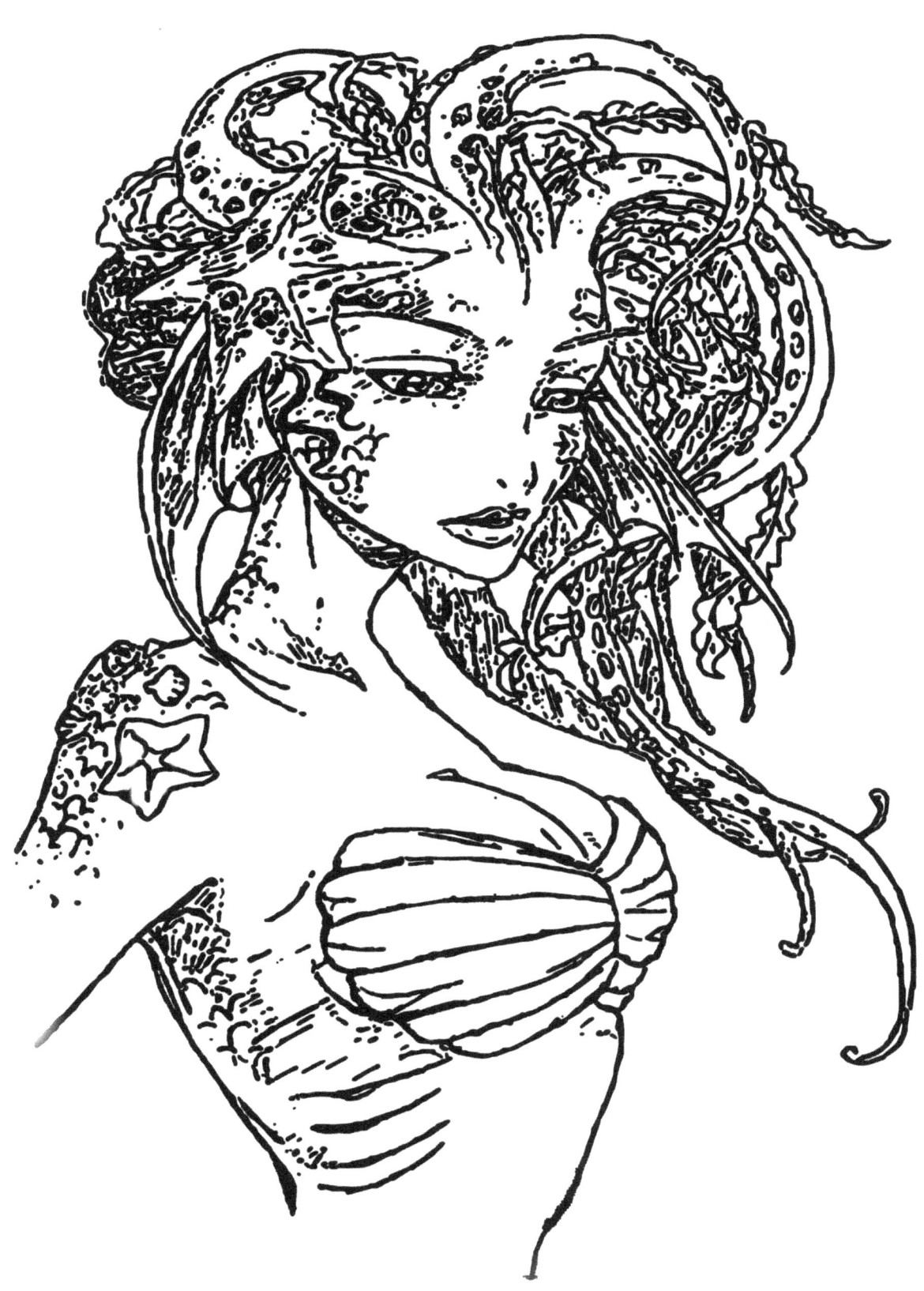

Blk Magick

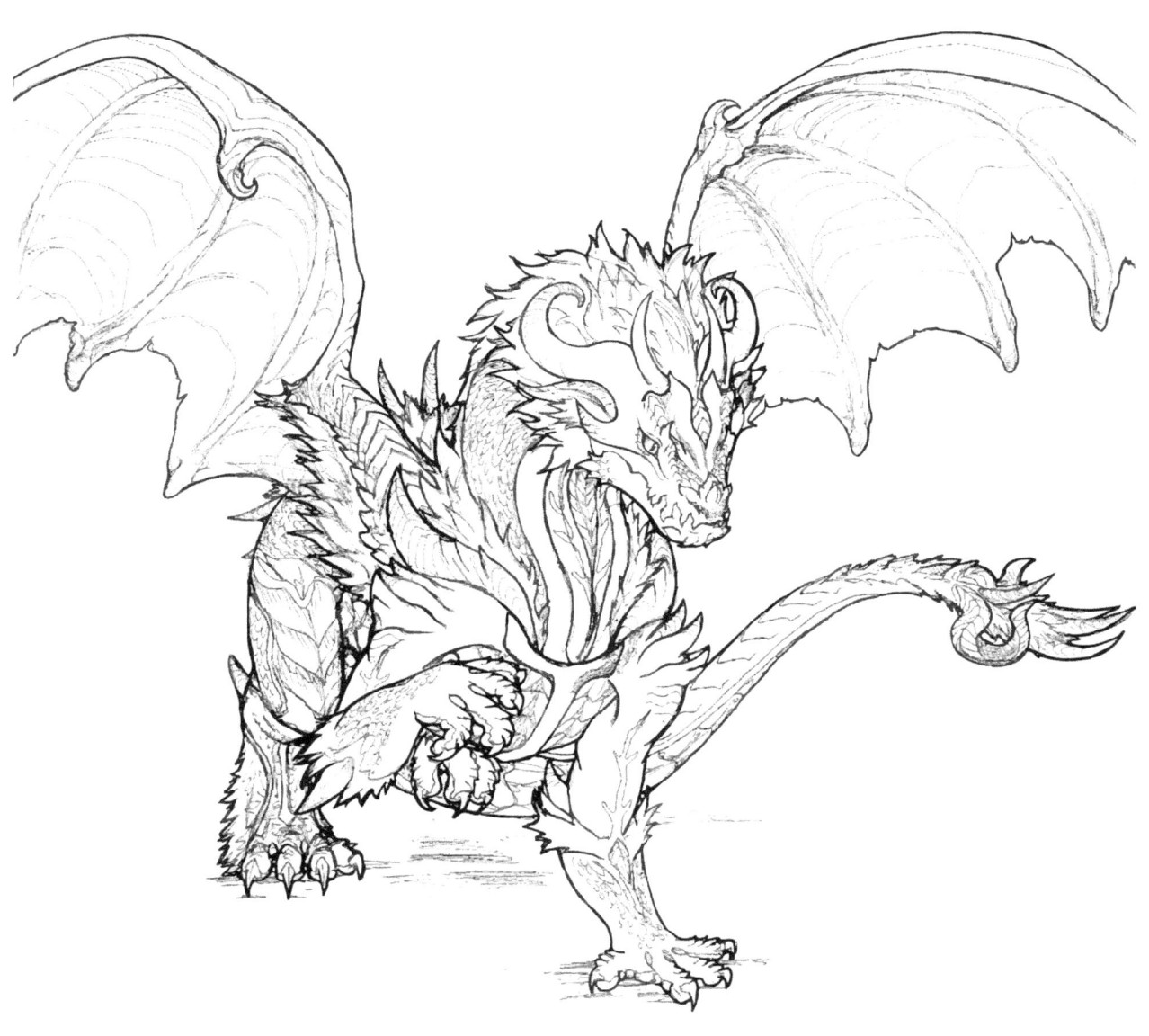

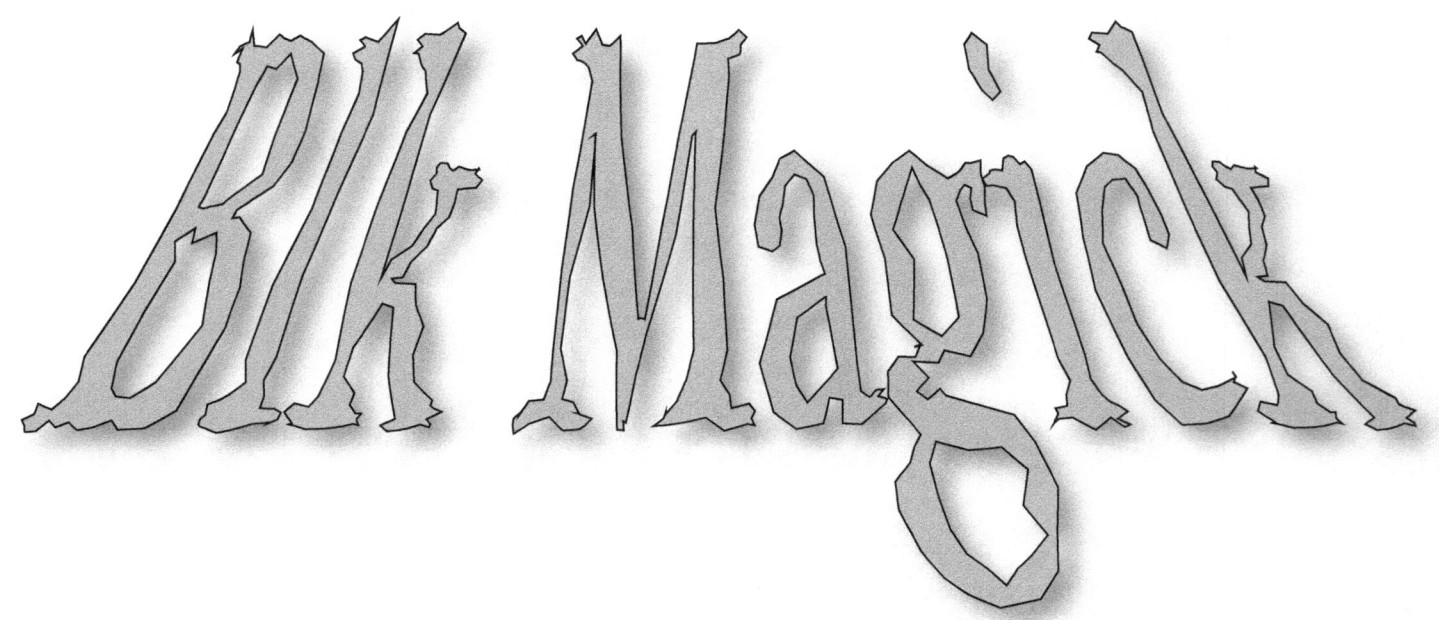

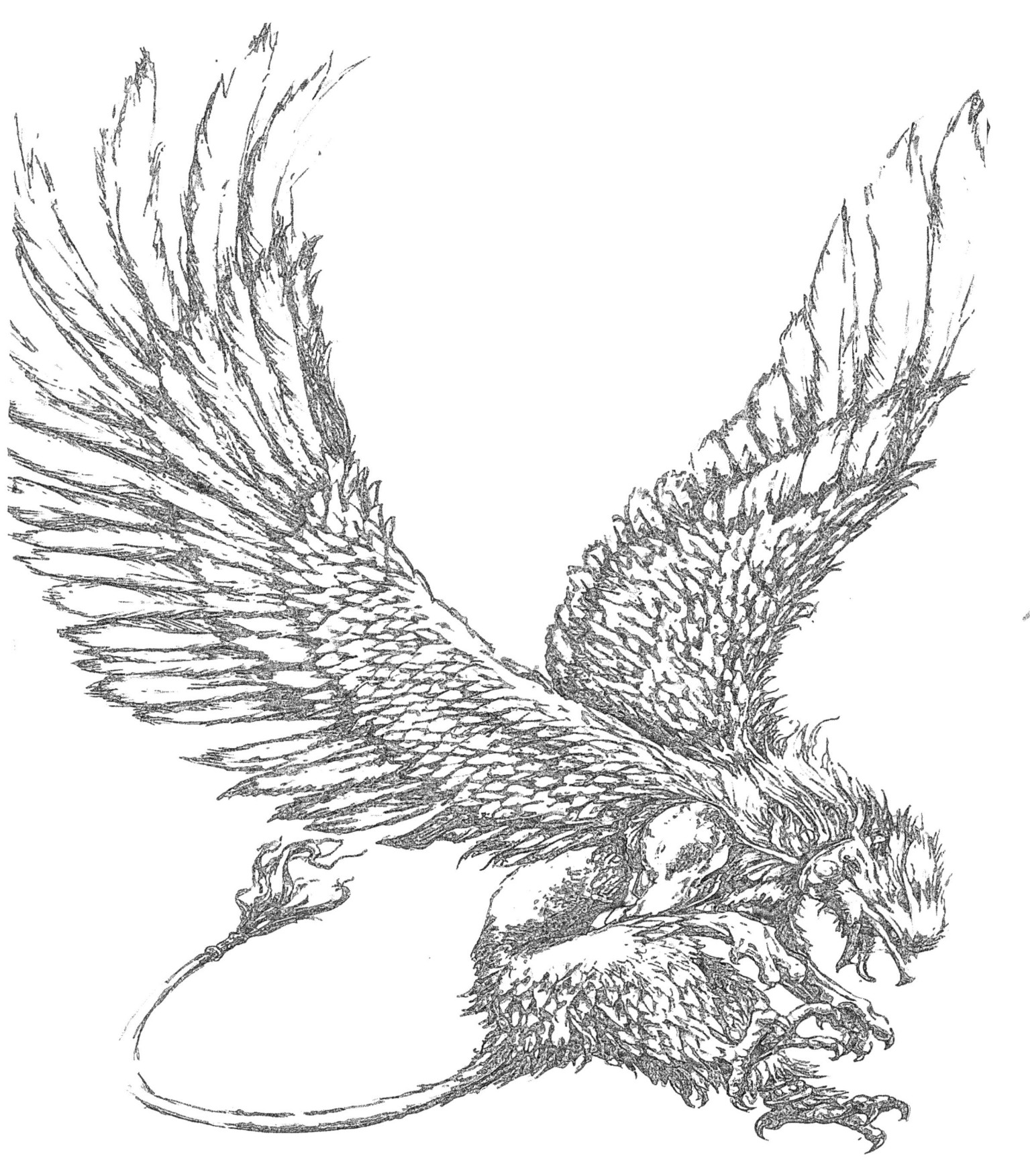

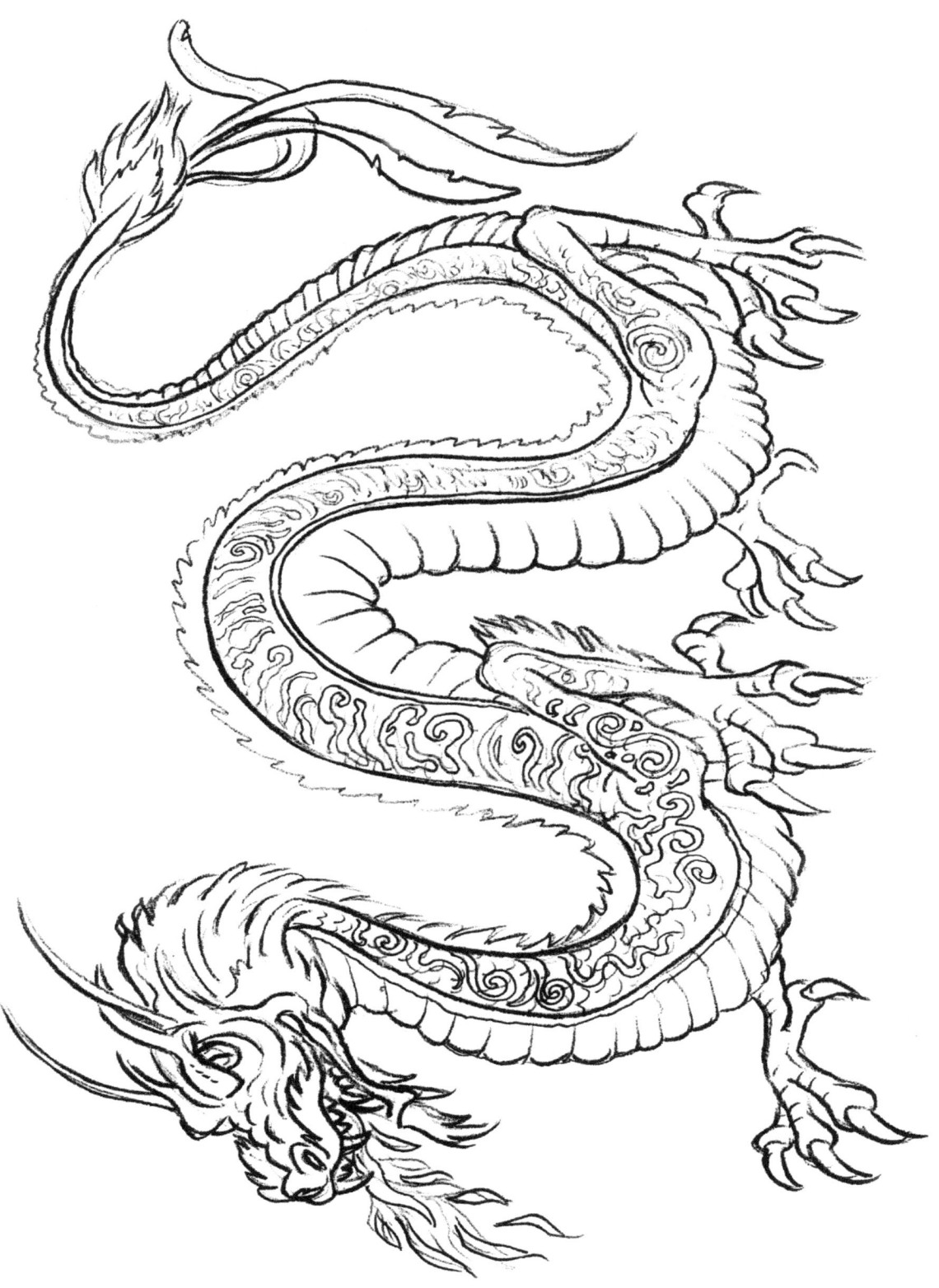

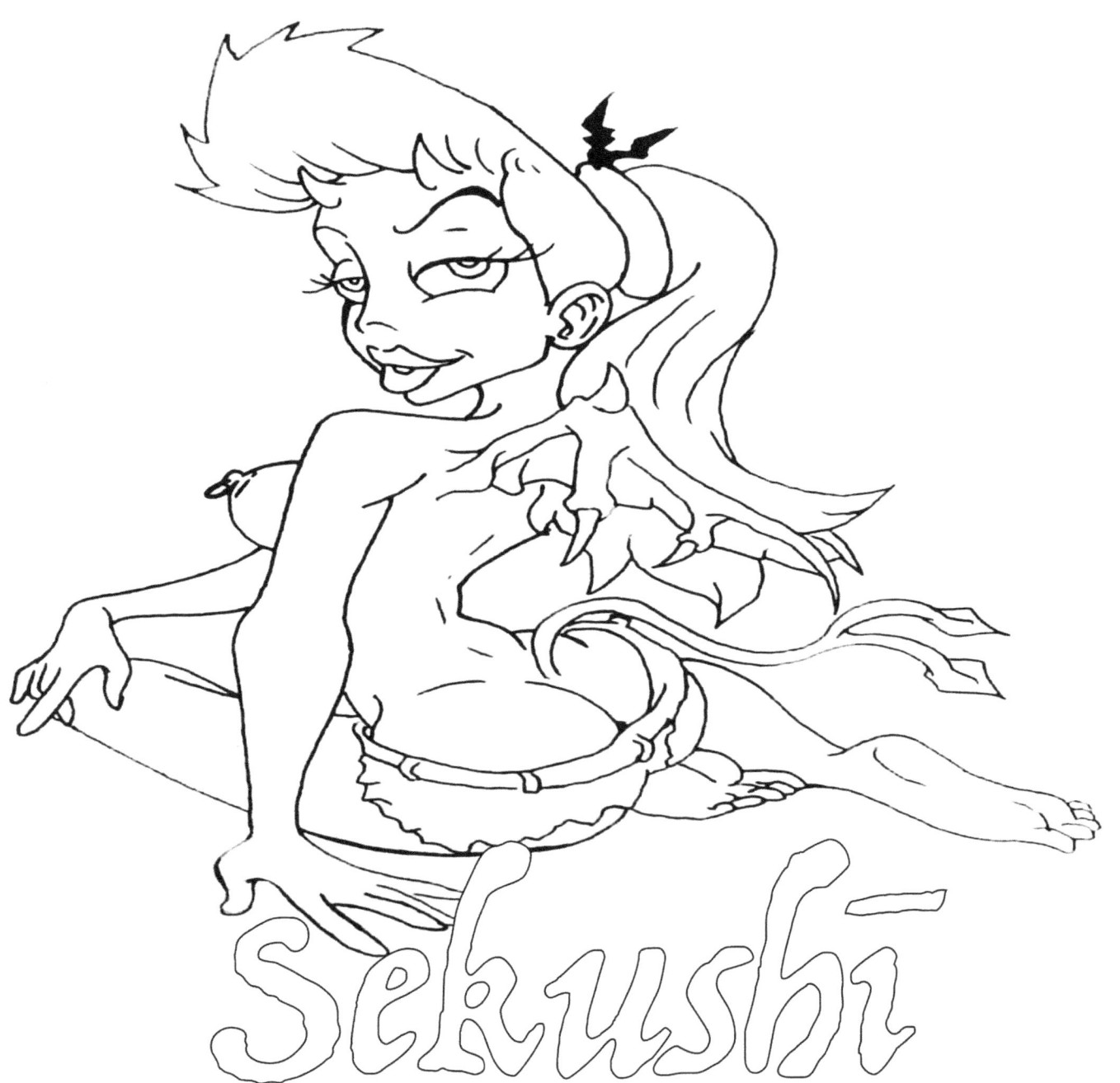

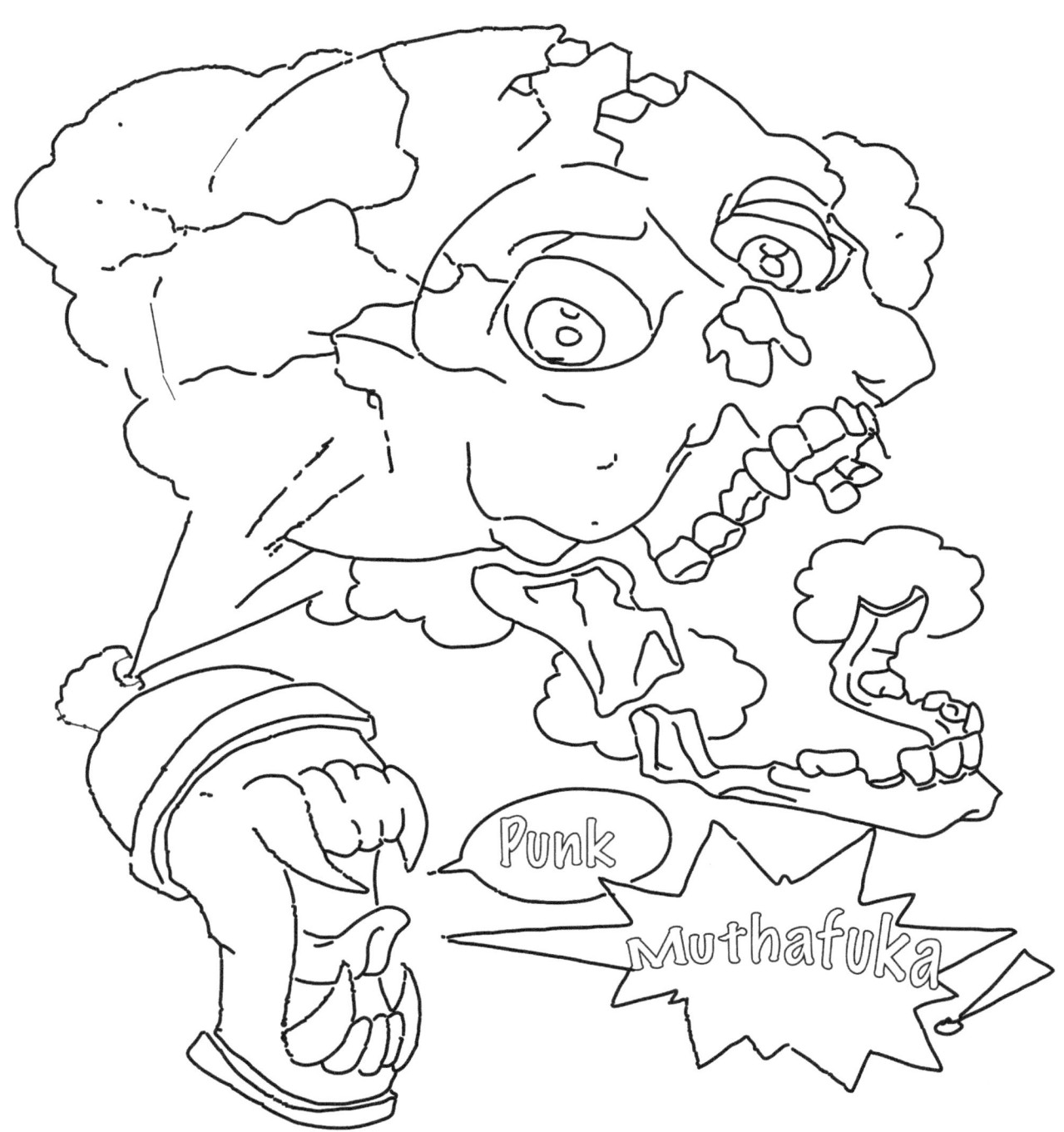

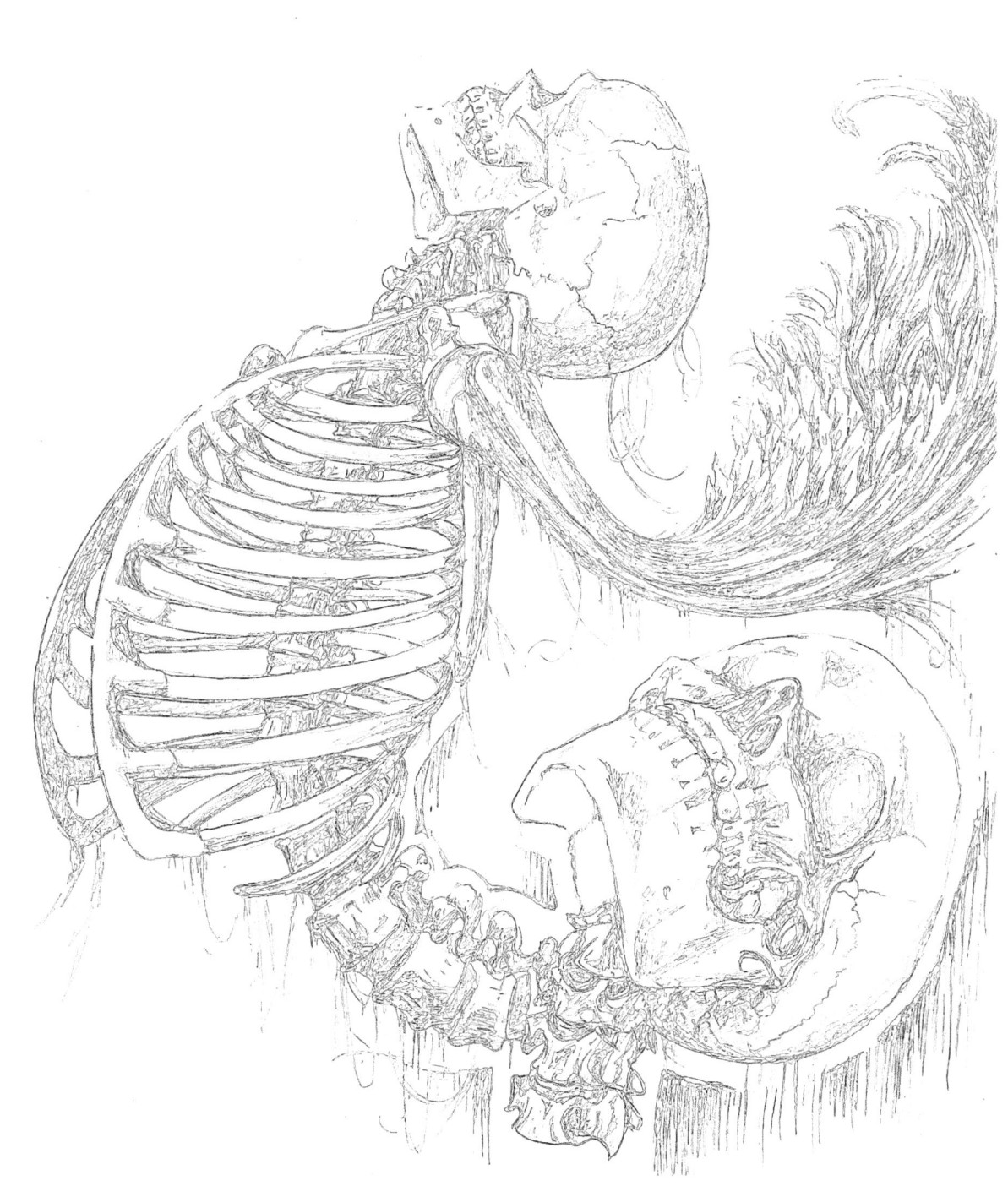

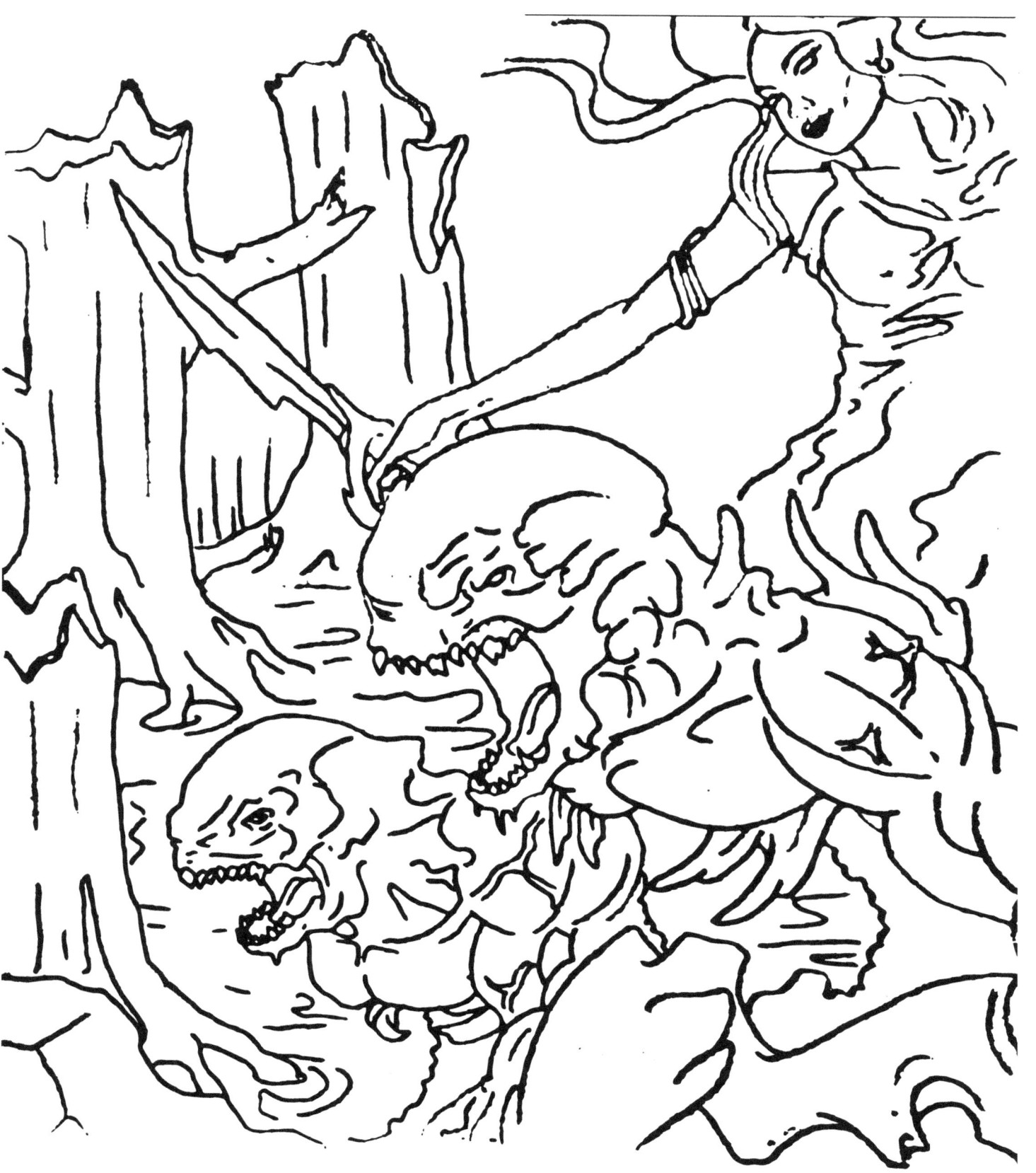

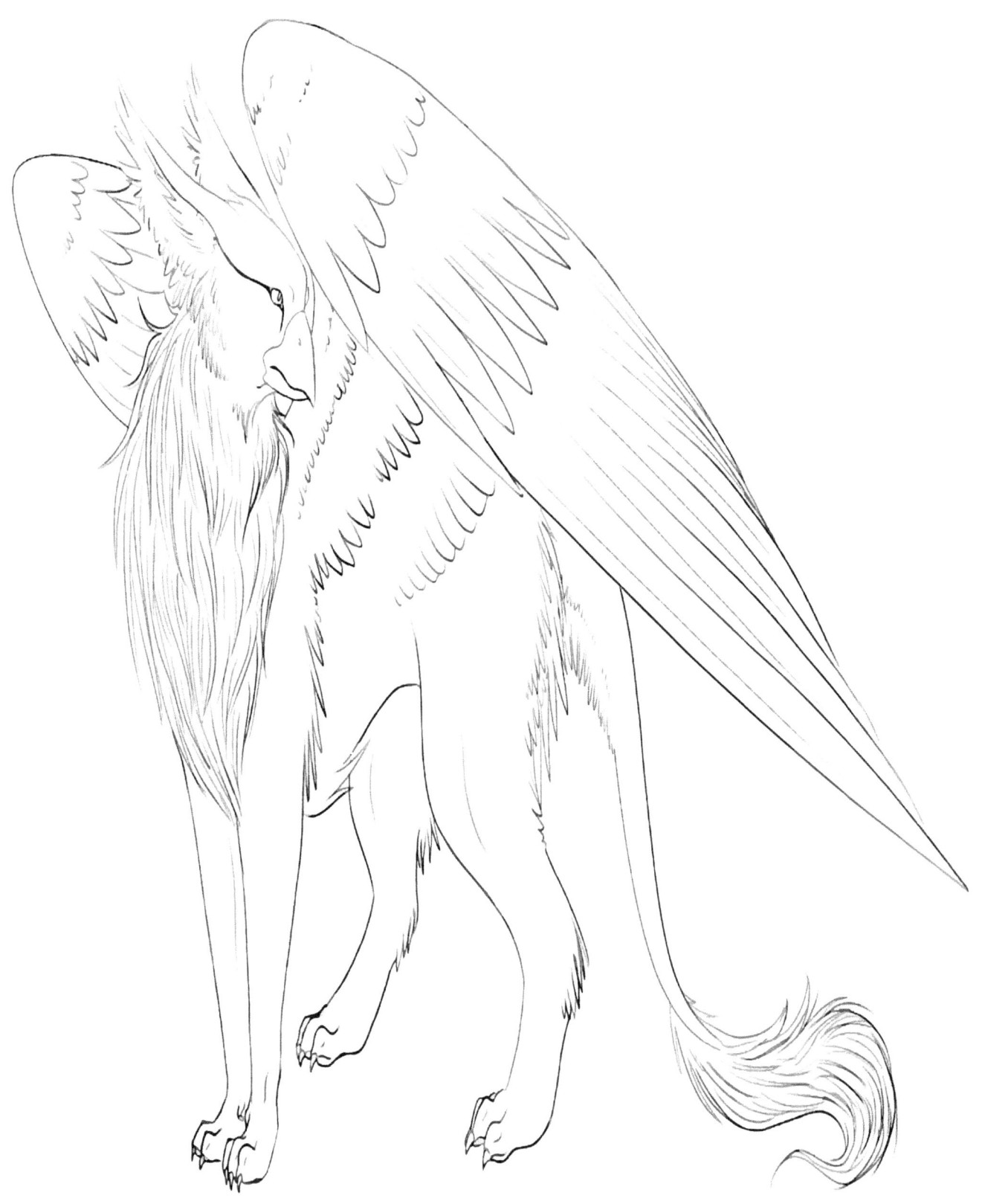

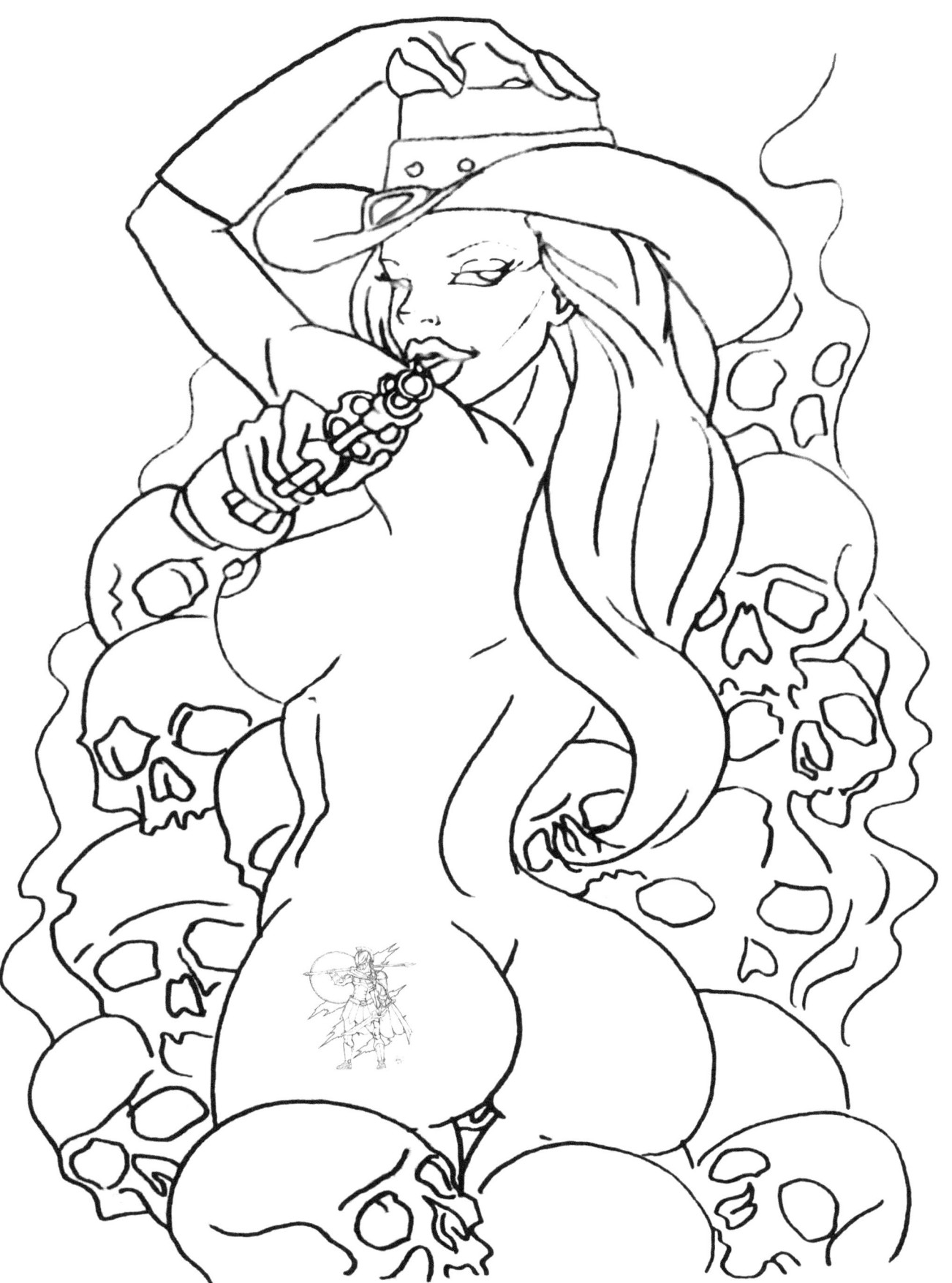

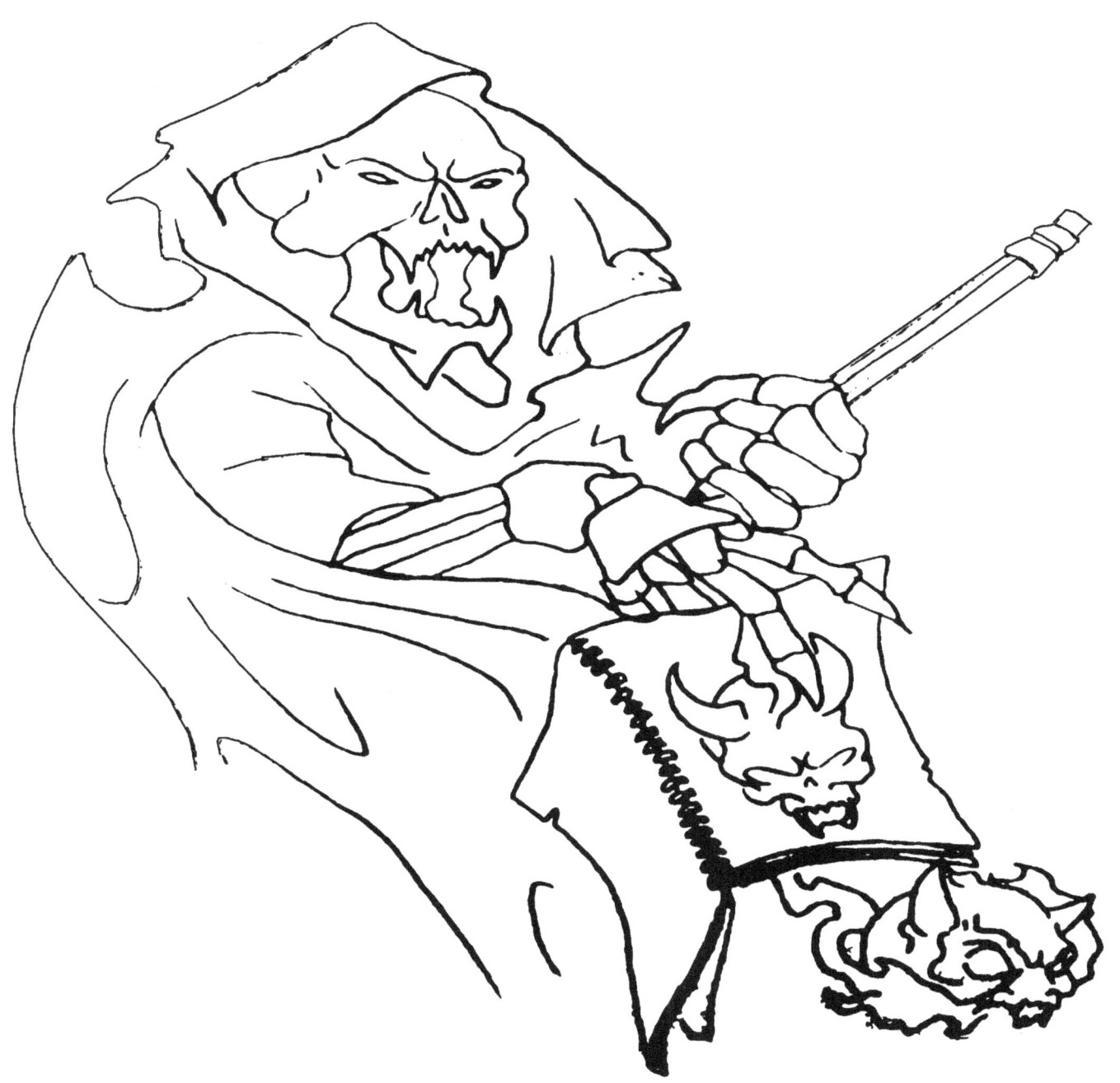

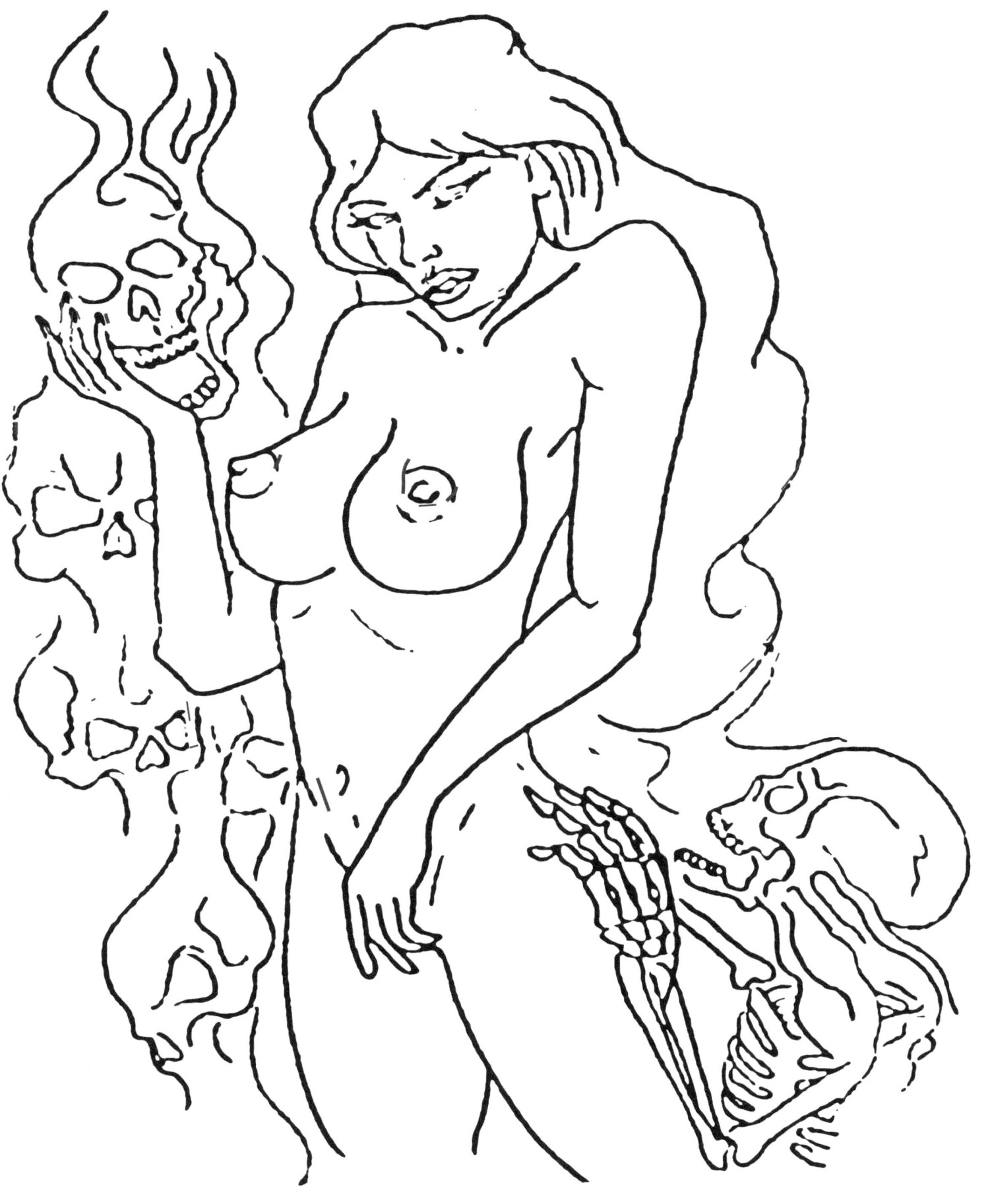

Coming Soon!

EPISODE 1: BLOOD

EPISODE 2: MOON

サムライ
KENZO

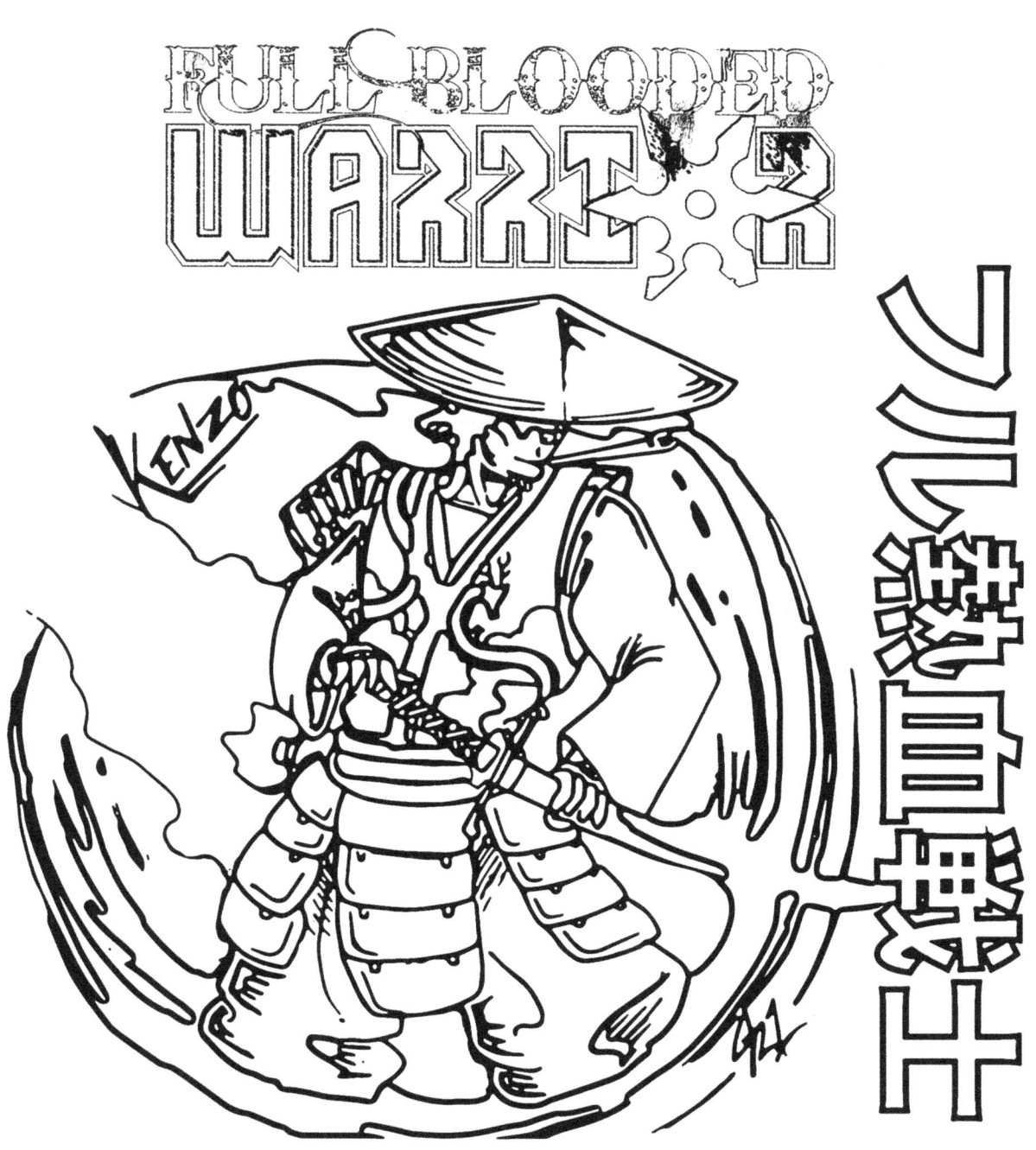

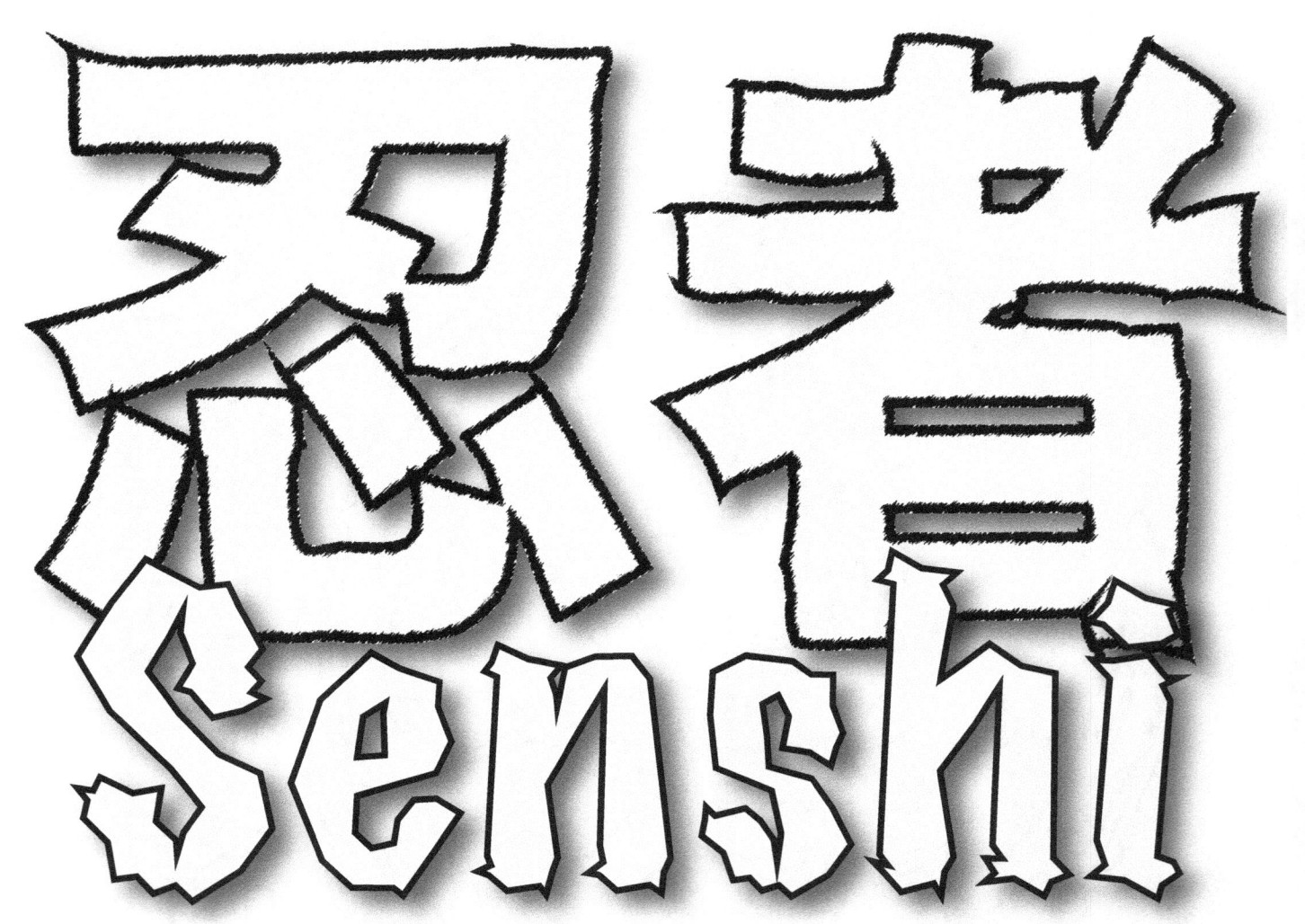

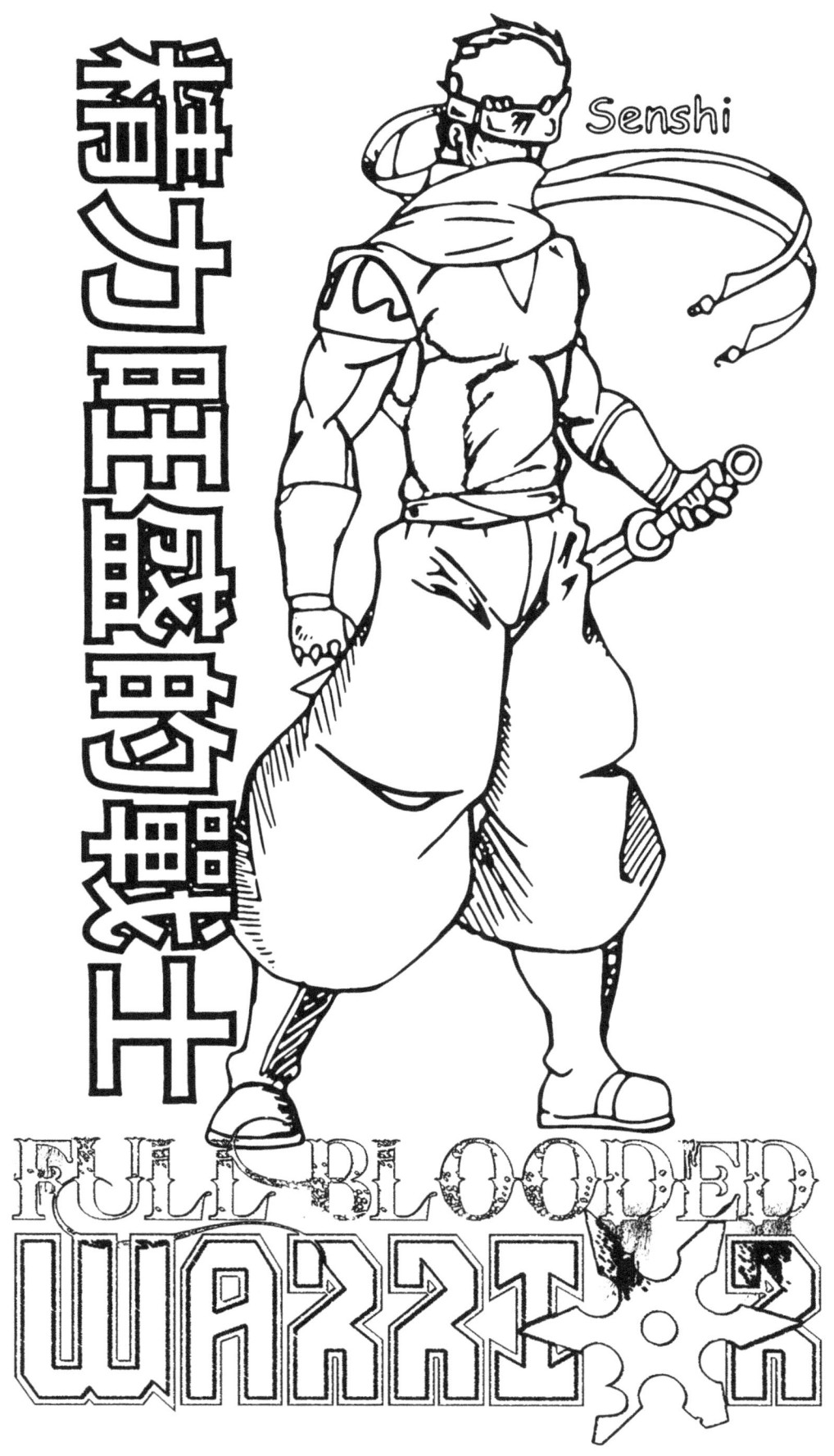

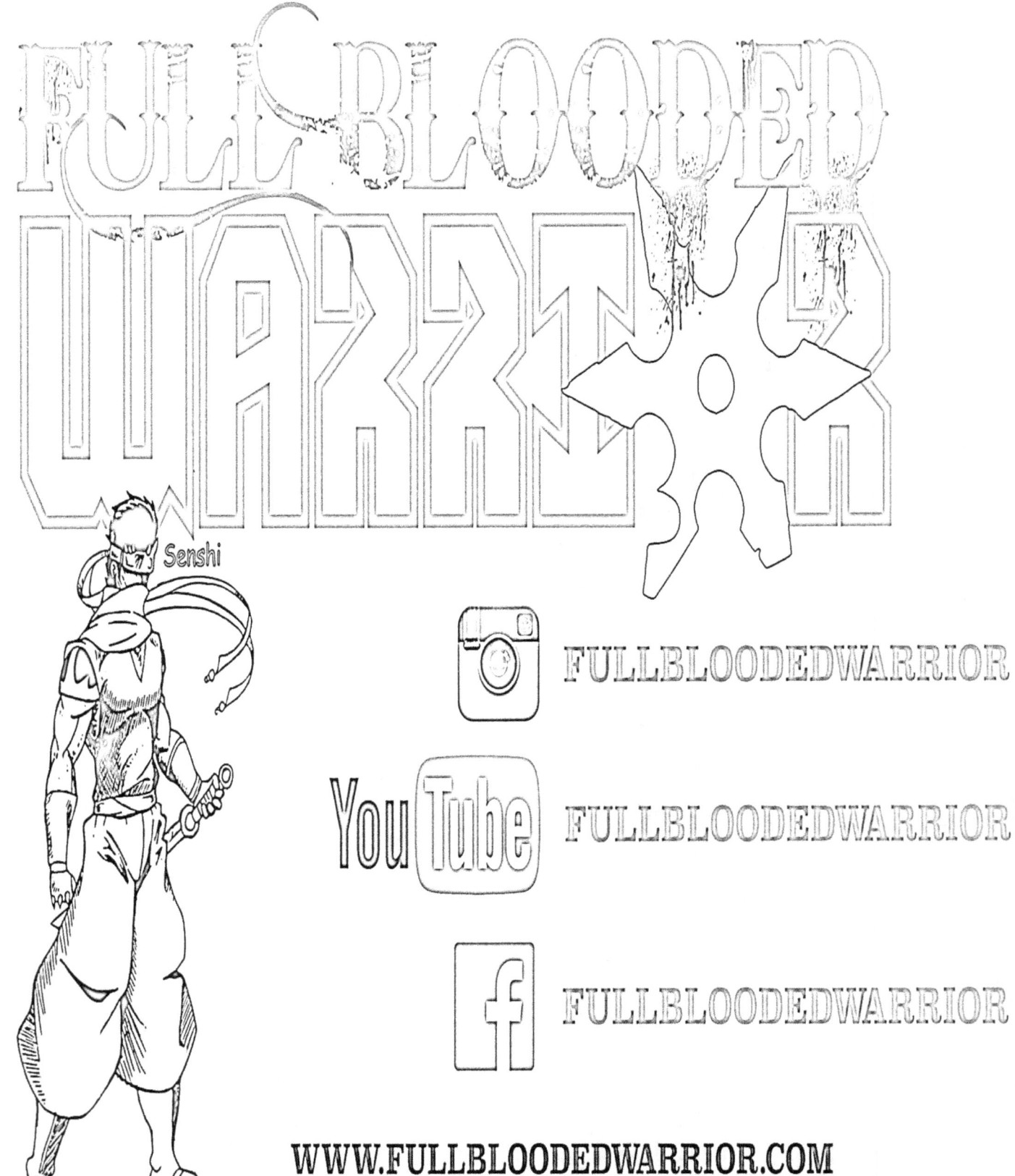